RA PRESS
100 Kennedy Drive #53
South Burlington, VT 05403

Cover art and photography
by Dave Donohue

Copyright 2016
all rights reserved
www.rapressrafilms.com

Showdown in Tangier

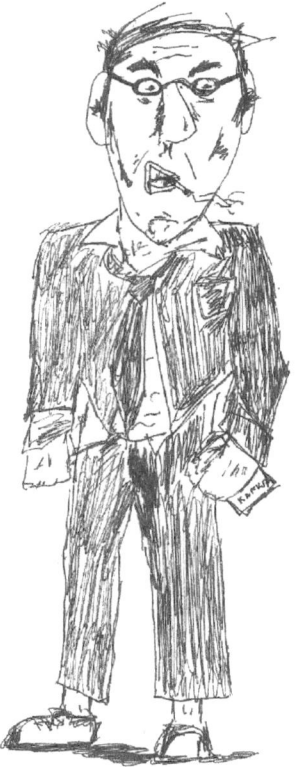

"Sometimes paranoia's just having all the facts."
William Burroughs

Neo-Beat Poems

Dave Donohue

This book is dedicated to esteban folsom - free spirit, mad neo-beat poet, friend.

HA

ha said the mime
with his body in rhyme
so this is the world of words
and flapping his wings
he started to sing
and took off
for the world of birds

e.f.

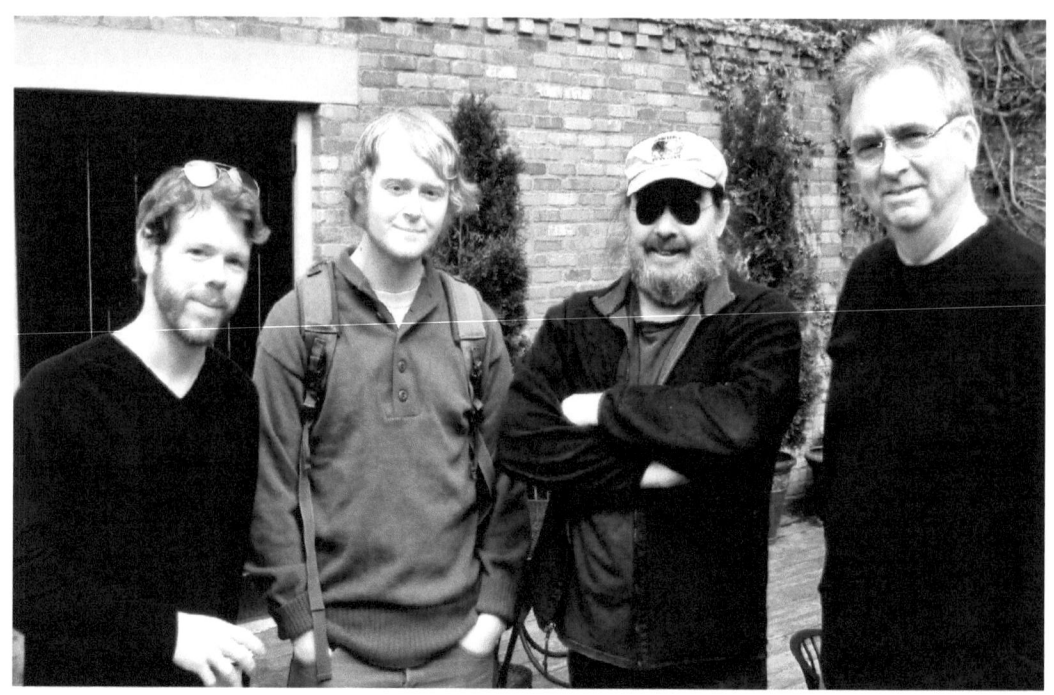

Neo-Beat Poets *(from left)* Christopher Ricker, Sean Tierney, esteban folsom, Dave Donohue

Cold Day
 Sean Tierney

City Hall Park
is far away today

an entire cold window
away

and inside
this room

a distance
like an ocean
between me
and you

On Burlington Poets
 Christopher Ricker

What poets write
 in the machine line
 of Fletcher?

In what Haiku's
 are their dreams made

 (of what colors?)

Introduction

It was early summer in Burlington, Vermont. Church Street. The 2009 Jazz Festival. My wife Shirley and I were in the midst of a crowd all swaying to the sounds of jazz on this lovely evening.

I looked about and thought - what a delightfully Beat place Burlington is! What delightfully Beat folk live here!

In that moment I began to think of Burlington as a new Beat Mecca - a Neo-Beat Mecca, in fact.

The next week we put out a *Call To Artists* in the local arts paper - SEVEN DAYS. People responded and by the end of summer our first book came out entitled WAKE UP CALL. Crow Book Shop generously became our headquarters for sales.

WAKE UP CALL would be the first of eleven neo-beat books that Ra Press would publish over the next five years. By the end of this small but vibrant movement some seventeen poets and artists would be involved in the Burlington Neo-Beats….

And now - to finish up - a twelfth book. This book. SHOWDOWN IN TANGIER. A joyride back through my own personal writings of the Beat kind.

A nice way to sign off, to say thanks and farewell.

 Dave Donohue
 January 2016

Sketches by Artist Andrew Becker of the Neo-Beat Poets reading at the Block Gallery & Cafe on March 24, 2012.

mantra
for the Burlington Neo-Beat Poets

bill, jack, allen, michael, diane, ted, lew, gary, herbert,
joanne, john clellon, carl, bob, lawrence, philip, ray, anne,
ed, neal, john w...

kings and queens of beat world emerged from 40s/50s
nightmare scenario conformity wasp versus red scare ala
joe mccarthy

broke from city/small towns/suburbs
 (all one *keep up with joneses buttoned down* world)
made a run, hop, skip, jump for freedom intellectual,
sexual, racial - bebop sounds of jazz

and now we find breakthroughs jeopardized
through world internalized via black hole internet,
predatory, false face book friendships, lonely,
love and lust humorless mechanical
communication twittering down blackberry lane,
humanity divorced from nature,
loss of meaning to our place in cosmos

sliding towards abyss of machine triumph over man
 humanity tossed aside

time to make for Route 66 of Soul
stick thumb out, hop in backseat
and howl our way to burlington of
 now-in-the-moment
 living neolithic neo-beats

Dobra Dozing
tea house mind walk

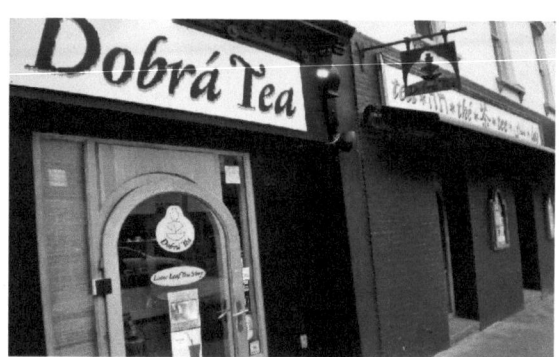

reflective
must have been late March afternoon light
through window teahouse
or maybe it was student seraglio of study in quiet corner cove
young women nesting in books
cay from Black Sea
dark Turkish Trabzon blend
that put me in mood of memories
of other places
and other times

Pudding Shop in Istanbul
where counterculture met going and coming
West/East ... Europe/Asia
London/Kabul... Paris/Katmandu
the faces of beautiful hippie women pipedreams through smoke and beaded curtains
a place of seekers and charlatans
travelers and burnt-out cases
a stopover of spirit and counterculture mind

teahouse Aleppo
narrow Syrian alleyway
early morning February
chilly in this ancient ville on Silk Route
narguiles, old men patriarchs, scene from a khayyam tableaux
legless man enters on powerful arms, moving table to table,
business-like, honorable, in search of coins and livelihood
as per Koran teaching

sunset, Egypt
Leave bustling cafe in back street Alexandria
Hop ancient tram car back to hotel
runs width of city on continent tip
shuttling through dusty debilitated neighborhoods of
rundown post-colonial glory
black woman in black robe with infant stands
begins musical lament in strong rich peasant voice
sadness strikes heart of darkness
within africa, within me

winter light through window
tea room sitting late in day
now later in life
life series of reflected thoughts

Walking with Gurdjieff down Church Street

The old man called to me from Crow Books doorway
 "Hello, Idiot!"
I turned and smiled, recognizing philosopher
 from his photograph.
Searing eyes, prominent nose, moustache,
 red tarbush cocked to back of his
 strongly sculpted skull
He looked well enough, even rested
Having been deceased these past six decades...
 "You're a long way from Paris?"
He smiled, then laughed,
 "Even longer way from Alexandropol...
 You. Me. Walk."

Arm in arm, we began strolling down Church Street
 Gurdjieff taking in the sights and wonders
"Women. Nice. Must teach. Work here."
"A receptive audience, I would guess."
He then began pointing to people's heads on both
 sides of the street.
"Those are ipods and earphones, G.I., for music and
 conversation."
He reflected on that a moment and then stated,
"Now people sleep. Their lives. With soundtracks."
"You nailed it, G.I.," I replied. "We have perfected
 the notion of blocking out our world."

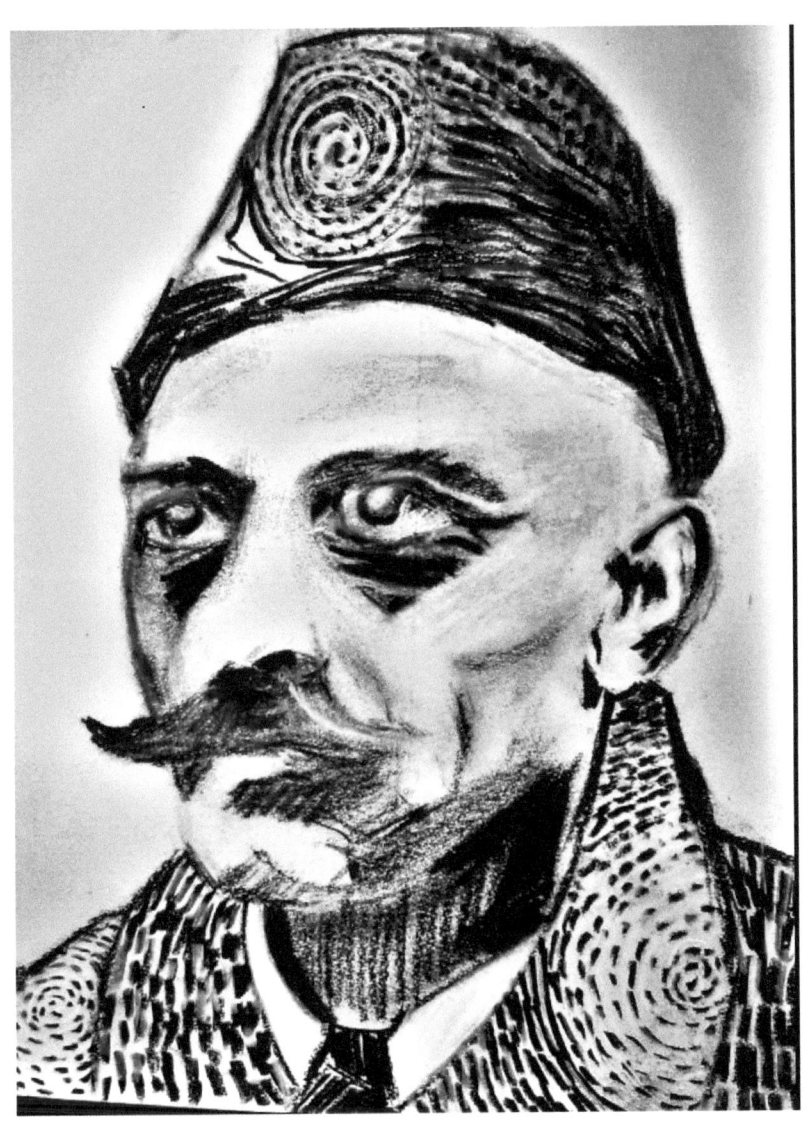

Gurdjieff by Jo Reis

At City Hall we turned round and Gurdjieff shouted
 "STOP!"
Before us, straight through to Church Unitarian,
 the crowd became ice
 as in *Simon Says*
I ran up the street, checking on the many
 folk in their frozen state, reminding
 them that they must focus on
 living in this moment
To my surprise I found a general annoyance from
 the group in the break to their routines,
 and our general lack of
 adherence to
 their personal rights.
"Part of the Work, " I kept repeating.
 "Part of the Work."
Returning to the Master, he then complained that
 what he really needed was an
 Armagnac at Leunig's
 and a thirty course meal...
"Death makes one hungry?" I queried.
He stared through me in reply.

We dined in several places to tally the required
 course load involved with the master's
 appetite.
From Chinese to Brazilian, Irish and French, Gurdjieff delighted
in the revival of his taste sense.
He spoke of remarkable men and remarkable places.
He questioned me of Burlington and wondered if he
 would be grilled about his work
 for the Czar.

He spoke of the Brotherhood, of the years in the
 wilderness, of his childhood in Kars.
The hours passed and my mind opened to this
 mystic man before me
So much he had seen, so much witnessed, so much
 taught
I longed for those days when there were seekers
 on this earth.

Gurdjieff performed his sacred dances in the park
 after dinner
His body moving dexterously and in patterns that
 would make a young Nureyev envious
Chanting at the same time to a mesmerized audience
Now encircling him by the water fountain
Fascinated by this strange character
From a post-Ottoman fantasy
I smiled in satisfaction that we had all witnessed,
 right then and there in the queen city
A glimpse of something very special
 in this post-miraculous world.

As he slowly dissolved before our very eyes.

 "Wake up and live in the moment."

What makes Burlington, Burlington

Heading down Maple and then up Battery
almost late for work on a Friday morning
thinking of things to do in day upcoming

I came to the light at Battery and Pearl,
and beheld a sight that symbolized the idea of why
burlington is burlington

a young woman, dressed fashionably
sailed through said intersection
floating dreamily on skakeboard,

with satchel over shoulder
she seemed picture of grace and composure
mixing professional with cool

everyone at intersection subaru collective, paused,
watching with admiration and awe
 bordering the religious
this testament to youth and beauty
living in her own moment.

Big Bang Bong Theory

god in room of ill-defined size
dimension not having been imagined as yet
room barren but for table, red button and device for
inhaling eternally lit weed
plus lighter
and chair for immortally stoned sit-down

god deep in thought about said button
whether or not to push
and split atom of creation to begin the process
of universe building
quiet in room, lit fluorescent-style
like a knights of columbus hall after bingo tuesday
nights

god inhaled and it was good
all peace and nothingness mostly
although a bit lonely in that eternity
he never questioned from whence he'd come
no need
but thought more constructively on the possibilities
of a button pushed
and its consequences

visions danced before his eyes
of galaxies, novas, planetary dust
of nebulae and saturn rings and martian rust
and then beyond that to specifics
like ice cream cones, low cut dresses and just about
everything corny and funny and cool and sexy

but there also came thoughts of a different disturbing
turn
of nazis and bigots and people who burn crosses
and greed and despair and death by natural causes
that each person's time would be a series of losses
what was he to do
for god's sake?

God reached for the lighter, it slipped, dropped and by
accident hit the red button
setting off the beginning
and before his eyes flew comets and cancer and carnivores and
crosses to bear forever
for at that moment, the very minute that time measurement
became a *minute*,
god realized he had also made his first mistake.

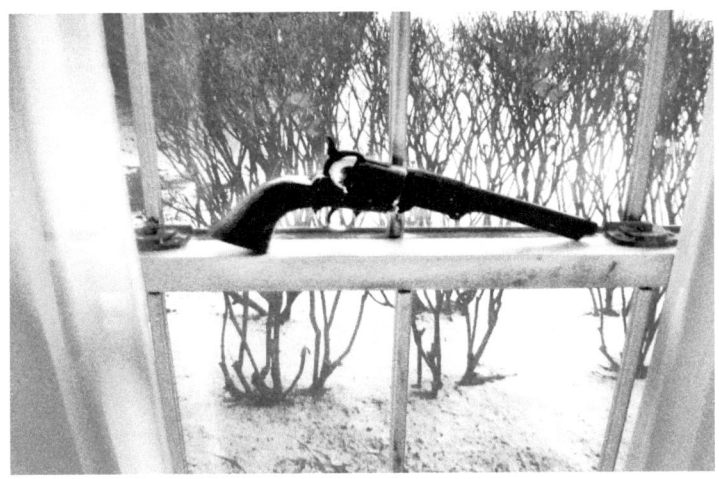

Back in the day
> *what I miss most...*

girls with long hair parted in the middle john hawkes the incredible string band the next brautigan novel allen ginsberg's om beatles alive, well and together eugene mccarthy the berrigans warhol's factory candlelight vigils

woodstock nation jeff beck's truth country joe macdonald abbie hoffman angela davis thomas pynchon james coburn movies peace signs hunter thompson communes chelsea girls album jackets canned heat kodachrome

bowles in tangier morrison love as an answer kennedys and kings carlos castenada kicking nixon around embracing the east melanie mailer as antagonist sylvia kristel procol harum siddhartha girls in bell bottoms

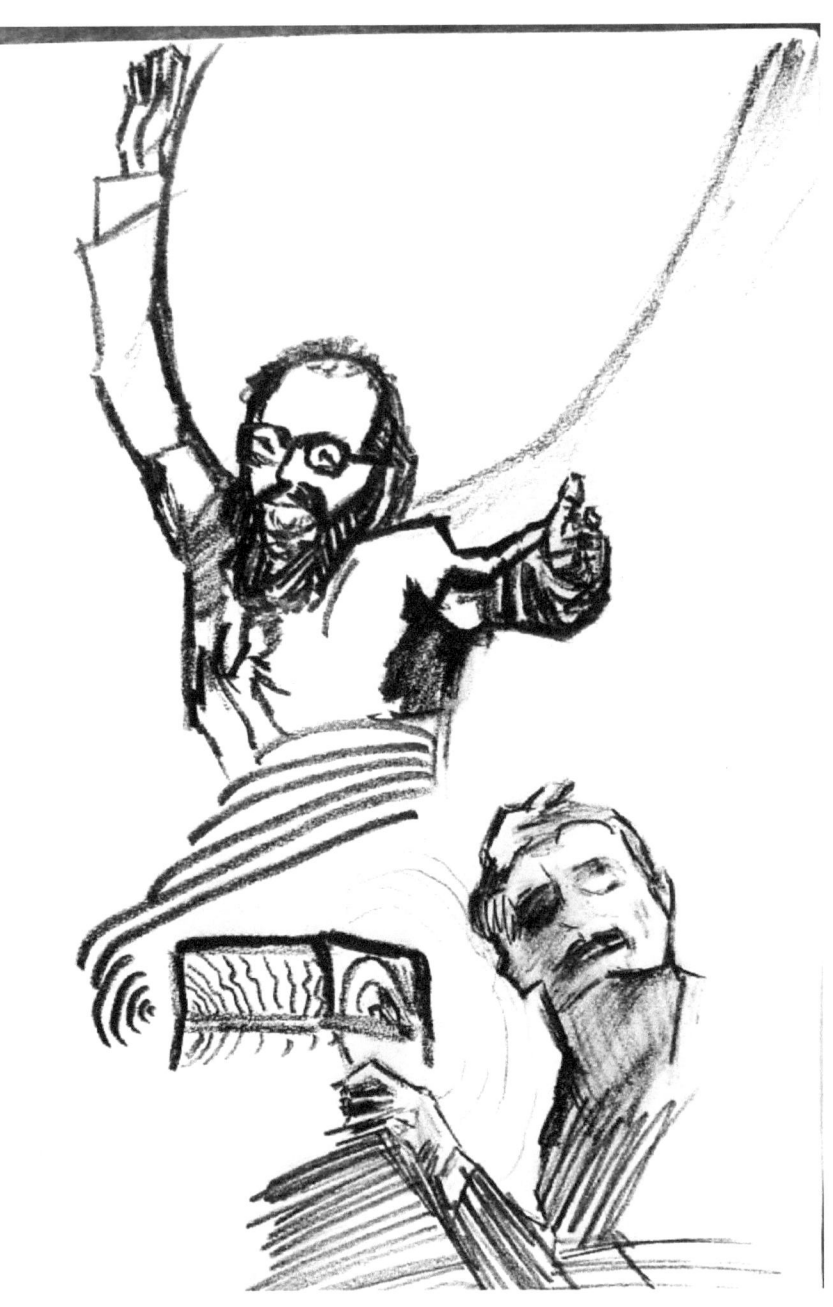
Ginsberg by Jo Reis

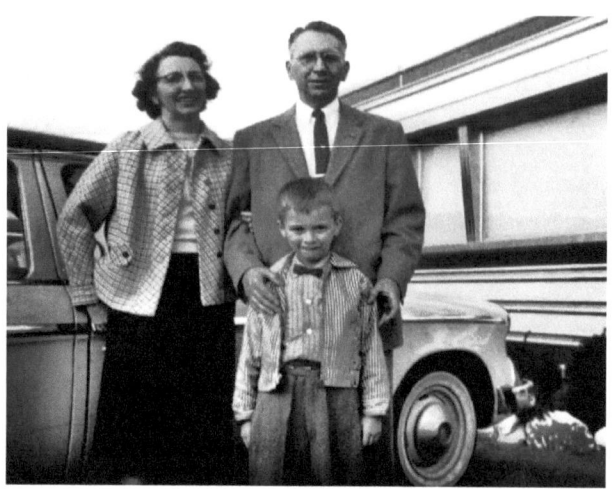

Jack Kerouac's ON THE ROAD was published in 1957. Neophyte Neo-Beat Dave Donohue was six years old at the time and his travels were focused around Poughkeepsie, NY with his parents in the family Studebaker.

Melting
(first beat poem by author circa 1966)

North Pole,
South
at the mouth foaming
freed water flows.

Studebaker Ragas
Poughkeepsie NY, 1957

1950's family collection photographs hunkered
 down on closet shelf
Many fading like memories of Poughkeepsie
 childhood people and places depicted
Show world black and white, conservative men
 in gray suits, women in skirts below
 knee, Cardinal Spellman approved.

I find one photograph that screams hues and
 tones, trying to break through colorless
 confines of the times.

Studebaker, 1955, canary yellow body, troubled
 bile green roof.
A plug ugly reminder of outlandish movements
 on those Poughkeepsie streets.
Up Roosevelt, down Corley, over Pershing and
 then out to Main and places exotic:

Red Oaks Mill. Pleasant Valley. Fishkill. White Plains.
A world mysterious, curious to a kid five years into the stream of
things conscious and otherwise…

Often wondered as the years passed if my dad
 had awful sense of color and design.
Or maybe, just maybe, Studebaker represented
 so much more to this quiet parent.
A vehicular nose thumb, a splash of moving
 rebellion, a cry out for cross-town

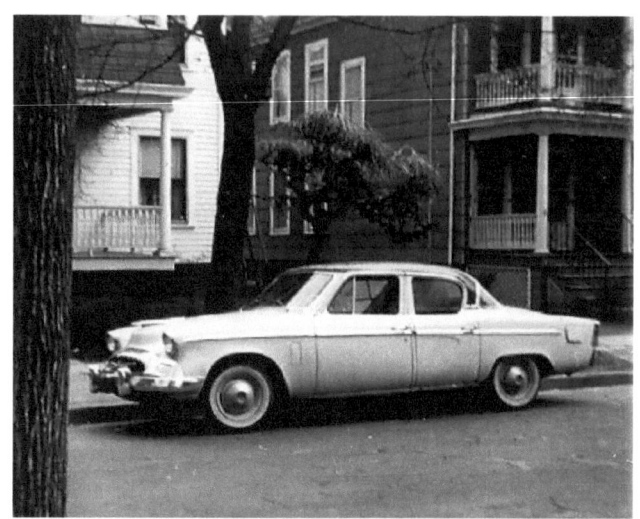

craziness.

In an all too conformity-driven world, maybe
 like Jack and Neal cruising cross
 country during the very same moments

There was psychic/poetic agreement in
 thoughts reckless, thoughts beat.

Discarded Photograph
Confirmation Day 1961

I received a call recently from my sister in Georgia who had been rummaging through old boxes of our family photographs in her home and had found one particular picture that had disturbed her. In fact, it had bothered her to the point that she had ripped it up and discarded it.

The photograph was of me on the day of my Confirmation in Fifth Grade. She said I had a terribly sad and confused expression on my face. She said she remembered that our mother was in a Burlington hospital undergoing a serious stomach operation at the time, that my dad was with her and that she could not recall where she and my brother were on that day. She could not remember being at the hospital nor could she remember being at the ceremony.

Being some six decades ago, everything is filled with the haze of time. I do remember my mother's illness and our concern for her well-being, but I also remember that a very kind man, a Mr. Mike Flannery, had been my sponsor for that sacrament on that day. He was the manager of the local A&P and lived around the block from us with his wife, son and daughter *(a very attractive daughter who also received the sacrament of Catholic adulthood on that day)*.

The family held a big picnic in their backyard after the event. I was looked after very well that day with lots of good food and good company. I do remember looking up towards our home (which could be seen through the trees of the Flannery backyard) often during that afternoon .

Still, though, I would have liked to have seen the photograph of me at that moment in my young life. Most pictures through the years represent us all in moments of fun - a Christmas or a birthday or a vacation - and almost never capture the little moments that may actually have helped to mold us, strengthen us, and help prepare us for adulthood and for whom we would eventually become.

when ozzie and harriet ruled the land

although world on knife edge nuclear obliteration
frequent daytime sirens on Poughkeepsie streets civil
defense practice runs
school kids hiding under desks for believed-in bomb
impact protection
same kids wondering if plane heard each night was
carrying same bomb, wiping out american dreamers

there was show we watched giving comfort
america's family thru fifties to sixties-mid
ozzie... harriet... dave... rick...
the nelsons... fun in suburbs american black and white
picture tube tv days
a belief in the serenity of the good life post-war
plotlines concerning homework, party planning, mix-
ups with friends laugh away an evening

we did laugh, we loved oz for offbeat rusty-voiced man
in sweater goofiness, harriet's omniscient beneficent
good-natured mom, dave's serious straight arrow
young man and rick's flat delivery and songs.
our lives comforted by this family
believing in fun, and in themselves *but not too seriously*
needing a break from madness gnawing away at fifties
world just below surface
to rise at end of next decade.

French Quarter Blues

Sleeping so soundly from Miami to Jacksonville. Watching that crazy guy in the Tallahassee station with the filthy black suit walking from ash tray to ash tray searching for a half-lit butt - smiling and chuckling to himself all the time. Listening to Southern sorority girls in the seat behind me, expounding on the sterling qualities of *Ingenue*. "*That Shakespeare stuff is too deep for my little ole head.*" Thanks for going Greyhound! Almost thirty hours from Key West to New Orleans. From a near tropical Eden to the heart of the Deep South. I was beat. A shave, a shower, and a non-commercialized toilet were what I needed most. It was raining and foggy as we pulled into New Orleans that early spring night in '74.

"Need a lift, Bud?"

I hopped into a cab and we were off into the old French Quarter night. The cabbie, a short black man in a Madras jacket, helped me get a room on St. Ann Street. The Place d'Armes. I unpacked, cleaned up, and set out for the crux of the legend - Bourbon Street.

Narrow streets. Voices from doorways. An eerie feeling that this was not the America I was accustomed to. No wide open spaces or Adirondack mountainscapes, yet, there was a thrill inside me while making my way through the old wet avenues. An almost European flavor. That was why I had journeyed here to begin with, wasn't it? Something new. Something different. Something exotic.

Coming from the darkness of the final turn into the light of Bourbon Street was like being plucked from Purgatory into the courtyard of heaven. This, a heaven of the senses. A Babylon where barkers stood outside clubs advertising their wares. Where girls' legs slipped through windows from swings onto the street, just over pedestrian heads. Where Dixieland came screaming at one from all directions. What's the saying - like a kid in a candy store? I walked in an amazed stupor - up and down the street several times before I finally decided to go into a club. The band finished their set as I ordered a drink. The only other customer in the place was an old drunk with his head on the bar. I sipped my drink slowly, waiting out the band's break. By the time they started playing once again a few more people had come into the place. The musicians were excellent but their attitude downbeat. They looked weary at what they were doing, pouring out their talents in this fashion - like prostitutes. Nobody really caring or taking notice. I finished my drink and headed back to the hotel. I was more tired than I had thought. The revelry could wait until tomorrow.

The next day was rainy and cool. I spent my time touring the shops and cathedrals and museums. Artists were on the streets painting portraits. Jackson Square was with both tourists and pigeons. There was a serenity to the old Quarter. The prices were outrageous but the mood quaint. The afternoon I spent on Canal Street in the city proper, enjoying the bustle of the sprawling modern city. I then headed back to the hotel to rest up for the night.

After a dinner in an Italian restaurant where two intoxicated middle-aged businessmen tried to put the make on every female in the place, finally causing a scene over the price of the bill, I wandered again into the night life of Bourbon Street. This time I decided to settle down for awhile in one place. I picked a small establishment that featured folk music and immediately proceeded to fall in love with a young woman vocalist from Kansas City. Her voice matched Joni Mitchell's and her music was inventive and entertaining. I drank one bourbon, and then another, and then another. By the time I had summoned the courage to walk over and speak to the girl, her boyfriend had materialized from out of nowhere. I stumbled out of the place into the roar of the Big Easy night.

I looked at the quarter differently now. No more glitter. No more joyful decadence. I began to see the place for what it really was. The alcohol had sharpened my perception and also my cynicism. Young runaways rolling in gutters. Slick dudes of all sexual with monkey grins on street corners. Hookers barely seventeen... lonely - skin and bones. American Dreams crashing down upon us. Seedy. Shabby. An old black hoofer danced around his hat for loose change. A young white tough walked on the hat and when the old man protested, the tough and his friends threatened him. The old man withdrew. Shattered confederacies. Dreams of the Old South filled with white faces in the garish light. Nostalgic for nightmares of the past. When my bus from Key West had stopped in Mobile, a white woman had stepped aboard. Discovering that the only empty seat left on the bus was one next to a black man, she had backed off and left the bus. The black people chuckled. Strength. Perseverance.

I entered a strip club to finish out this madness. Within minutes I had been ripped off for twenty bucks. The show was grotesque. A large group of well-dressed Texans were having a great time, however. Applause. Several of the wives seemed embarrassed. I left.

This was not the way it was supposed to be, goddamn it. The fog was thick and the rain like a long beaded curtain. A 1930's horror film. Losing my way back in the labyrinth of alleys, I looked to the gutters for a ball of string to deliver me like Theseus. My shadow a Minotaur. Thoughts from the Cretan past. Loneliness through the ages.

The following morning I headed north.

NORTH AFRICAN SOJOURN

Cafe France
Marrakech 1984

Sitting there in dark glasses
the old Berber
memories mingling with the traffic mugging by
(African noon-day heat)
did reflect upon the life spent with both desert saints
and city thieves
Allah conducting quietly in the East.
"Another mint tea?"..."Yes, one more mint tea."
the chaos of this Marrakech
home now for some eighty years
where men lead lives of noisy desperation
(Quite unlike our Western kind)
the old Berber, sitting there in dark glasses
waited for a sign
and continued his psychic search for some rare
archaeological find.

The Medina
Marrakech 1984

Squalid, cramped
Streets twisted... a killer's mind
Where life comes screaming in frenetic waves
 And paves the way of the medina
I wandered... no, ventured...
 one dead summer's night
To see if God was still interested,
 still worth the fight
He was there by the pushcart, weary, quite grim
He'd aged a lot since last I'd seen him.
I asked how he was getting on
 (with poverty, with disease)
But he just smiled, put his hand out and begged,
 "Please,
 A token for Allah
 Allah be praised."
A dirham I slipped him
He nodded, unfazed.
I moved on quickly,
 through the night, through the dust
 "It's only the medina,
 nothing is just."

Rotund Tourist in the Toubal Lobby
Marrakech 1984

He hangs about
trying to avoid his vacation,
frightened, really,
of the African outside.

He has catalogues about software
and things American he shows his
fellow tourists
(*as if they could give a good goddamn*).

He's fat, oh, is he ever fat,
blends in well with the overstuffed
furniture in the hotel lobby
(the lobby he never ventures from).

He counts the days,
trying to sit out his vacation
making up stories to bore his friends with
upon his return.

He'll talk about his African
adventure for years to come,
giving eyewitness accounts
of the heart of darkness.

If only he'd take a short walk
outside the hotel grounds
Having traveled thousands of miles
 to come fifty yards short.

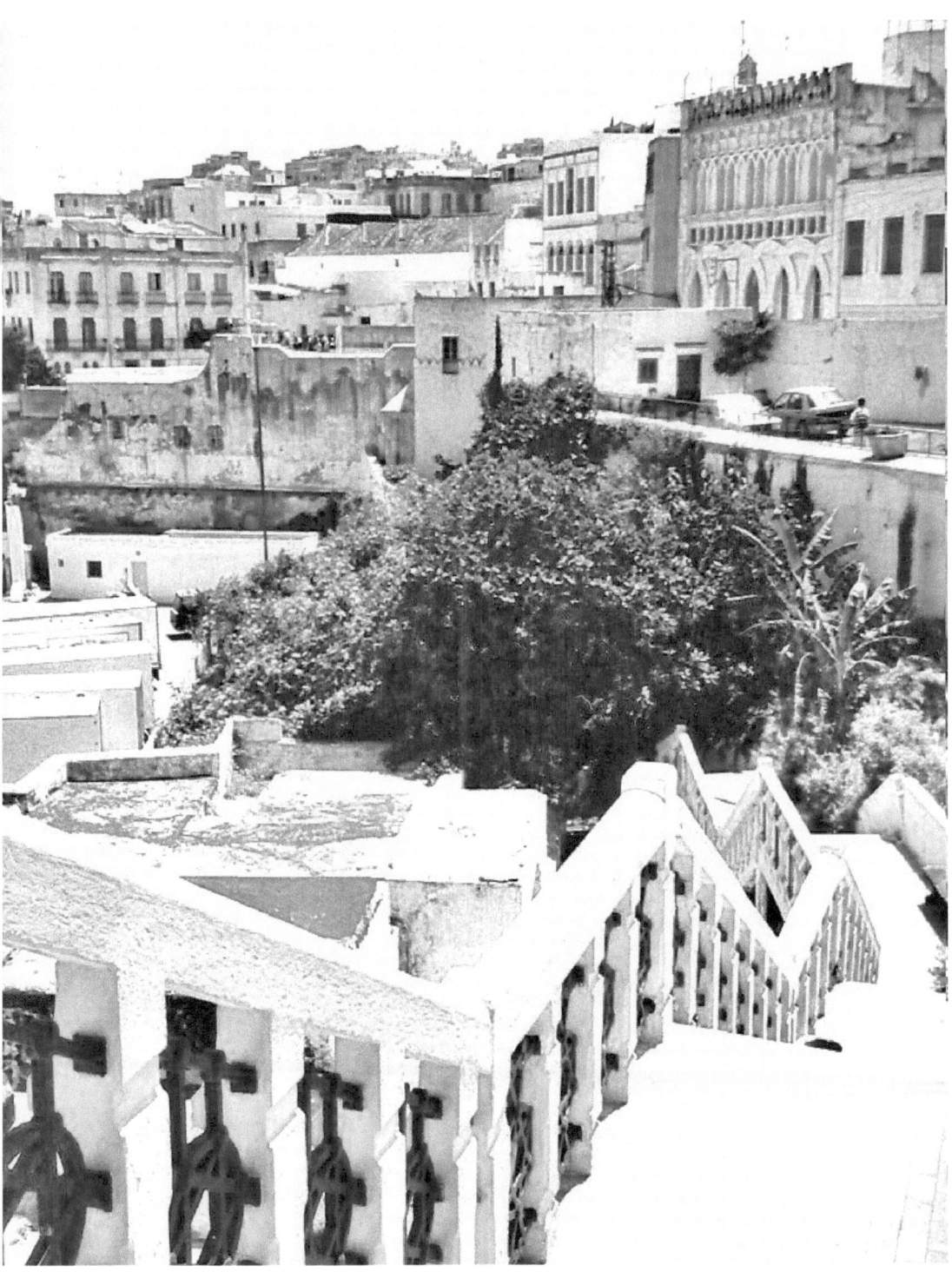

Showdown in Tangier
a poem for William S. Burroughs

 with gun in hand
 hand in pocket
 like some gawky bird gangster
smuggler no doubt
 the dope trade, yeah
 that would work
making way down alley - dark...
 voices from unknown corners kasbah
no, not *her* voice
 although it was always there
inside... running commentary on his strange life
 documentary of decay and alienation
black and white, slow motion
 writing will save you, Bill

 need junk. dead cash-flow time of month makes you live
off opiate dust and kif.
 makes you hurt bad til the next check arrives.
life reptilian automatic instinctive survival
 not lonely. not sad. not quite anything.
lurking about down alleyways
 day after day.
 as if there be a mission
 to these antics - literary, sexual, pharmaceutical.
pages falling randomly from typewriter
 about hell and mind control and torture and assassins
and the good Dr. Benway
 hand grips gun tighter

It's all quite simple. End it tonight, Burroughs,
 or write on and never look back again...

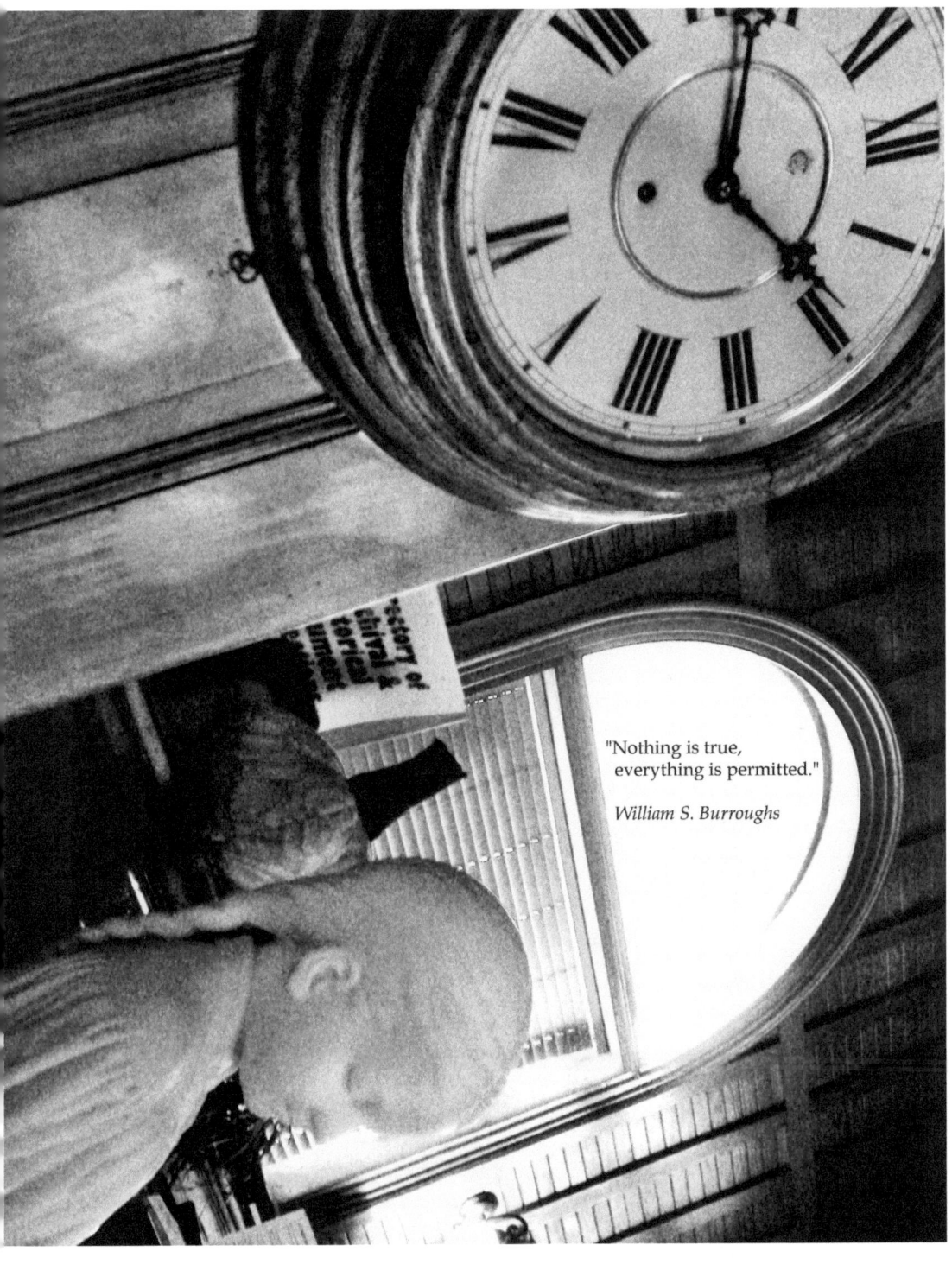

"Nothing is true, everything is permitted."

William S. Burroughs

The neo-beat poets burlington series

WAKE UP CALL (2009)
 Jodhi Reis, Mary Randall, Devin Michael Courtney,
 Esteban Folsom, Dave Donohue

MY Ill-READ OPHELIA POEM (2010)
 Sean Tierney

LAWLESS ADIRONDACK HAIKU (2010)
 Sean Tierney

BACK FROM BROOKLYN (2011)
 Kate Mohanty

CARPENTER'S DAUGHTER (2011)
 Christopher Ricker

ROAD POETS (2011)
 Sean Tierney, Christopher Ricker, Charles Watts,
 Steve Coe, Mary Randall, Dave Donohue.
 Carl Danelski

EL AAIUN (2012)
 Dave Donohue

WHOA WINOOSKI! (2012)
David Parkinson, Hannah Clark, Matt White, Dave Donohue, Christopher Ricker, Esteban Folsom, Justin Grimbol

DOUBLY STRANGE FOR THE SWEET (2013)
 Sean Tierney

HURTLING TOWARDS INEVITABILITY (2014)
 Robert Barton

IRON CITY (2014)
 Christopher Ricker